Inspirational

GOOD VIBRATIONS!

art
UNPLUGGED

A NATURAL
SOURCE OF
HEALING

This EXPERIENCE belongs to:

my 2 Grandmum Nov. 2016

©2015 Art-Unplugged

Design by Dana Wedman

This book is not intended to as a substitute for the advice of a mental-health-care provider. The publisher encourages taking personal responsibility for your own mental, physical, and spiritual well-being.

Correspondence concerning this book may be directed to the publisher, at the address above.

Look for the entire series of art-unplugged journals.

ISBN: 1940899044 (Inspirational)

Printed in the United States of America

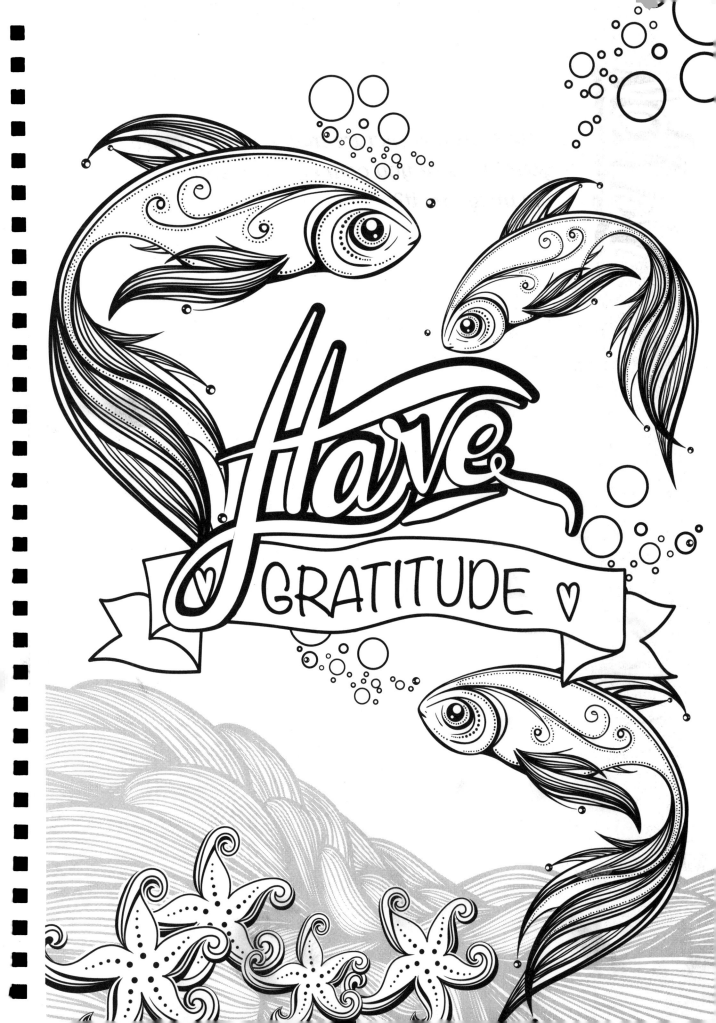

What are you most grateful for? How can you best express it?.

Paul Zimmer

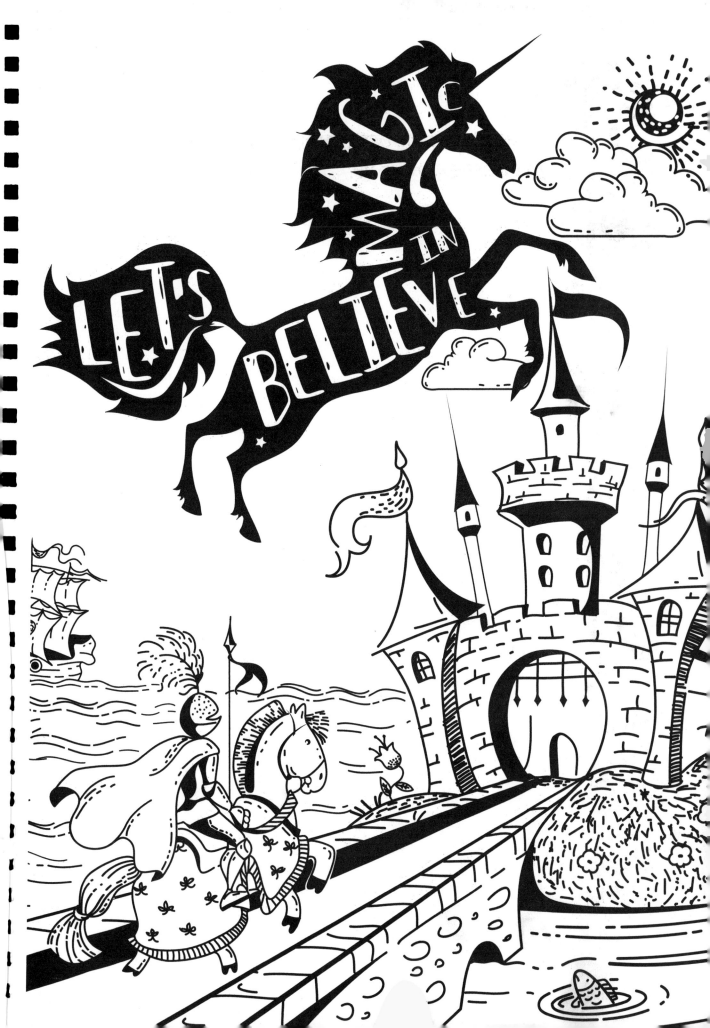

What does this picture make you wish for? Have you ever wished for that before? What do you believe helps wishes come true?

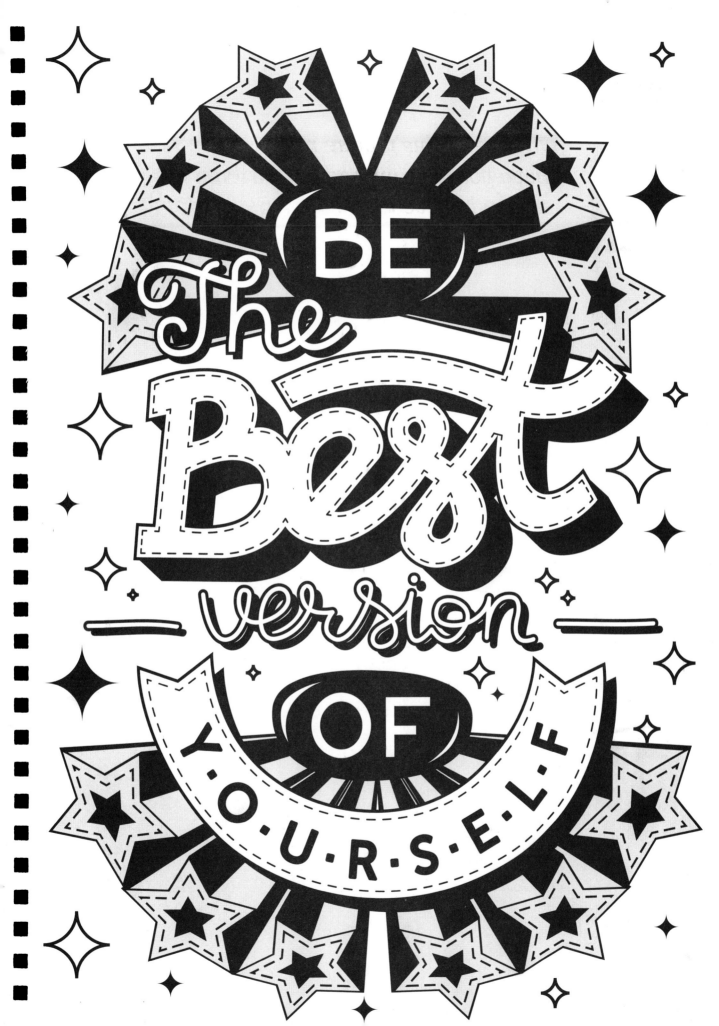

Who or what encourages you most to be yourself? Who encourages you to be your best self?

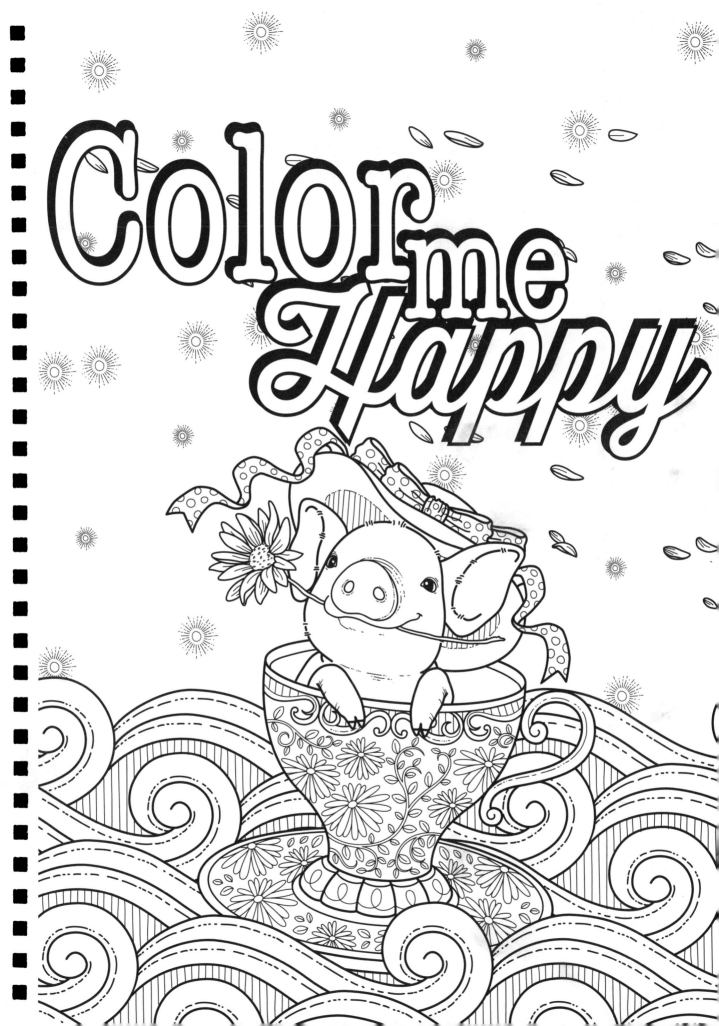

Do you find yourself coloring more when you are happy, or stressed? Bored, or nervous? How does coloring help you? How does coloring distract you? Do you consider it a good way to channel your energy?

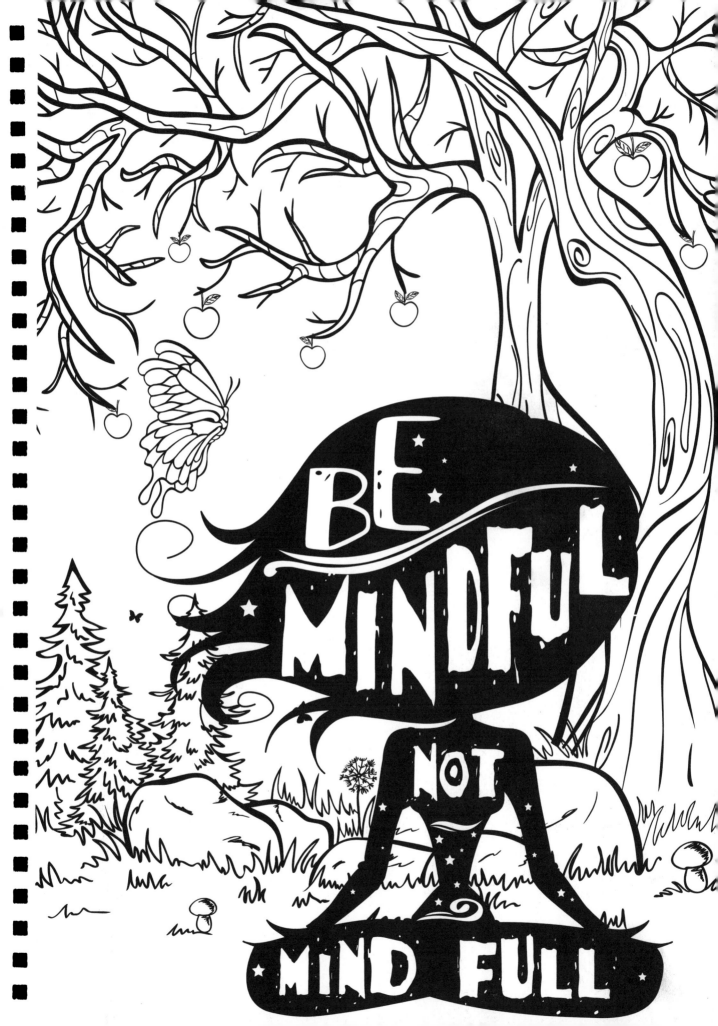

Minds are full of complicated mazes of thought patterns. Write about just one good thought that will be your focus for the day.

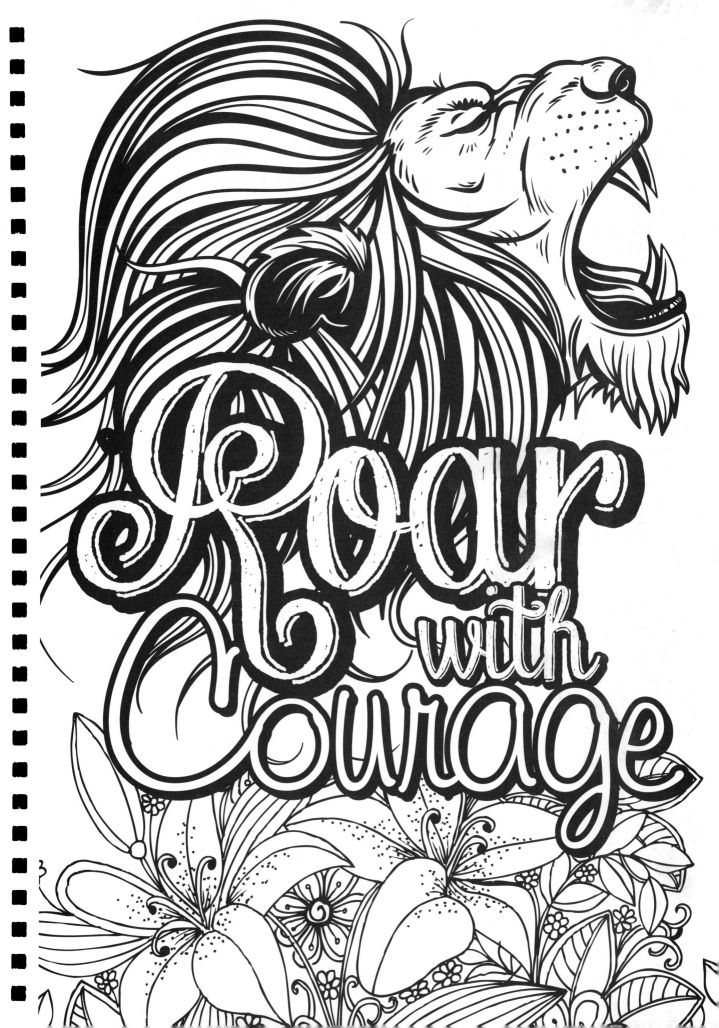

Courage is not judged by the magnitude of the act but the greatness of the heart behind the act. Write about one act of courage you are committed to.

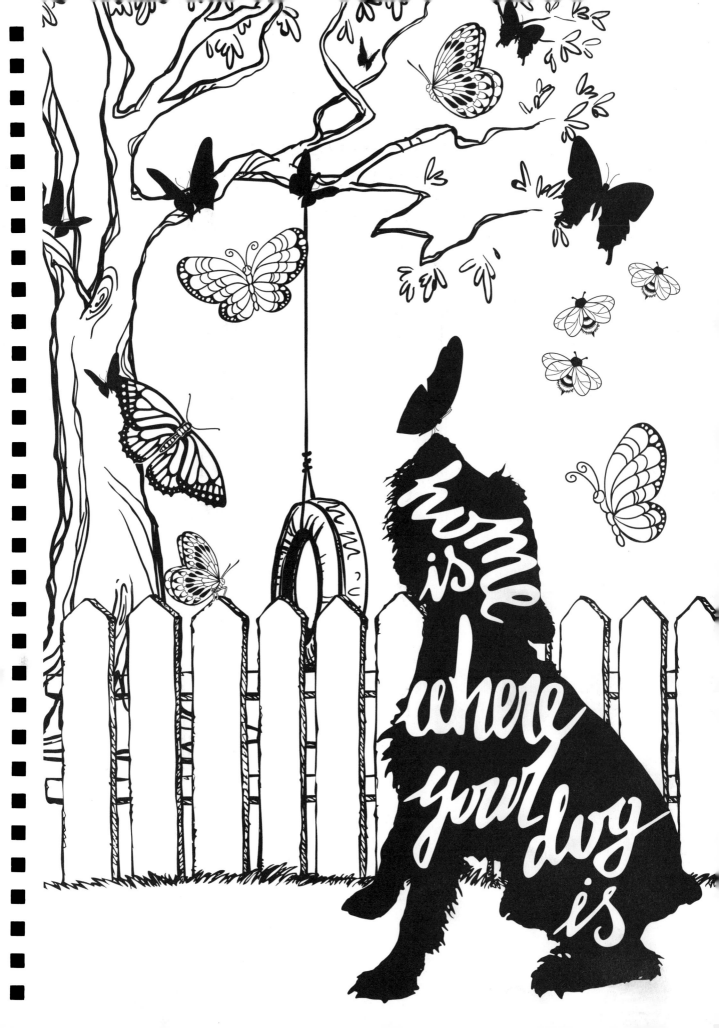

Nothing is Impossible

Does coloring calm you and comfort you? Describe other practices that make you feel calm.

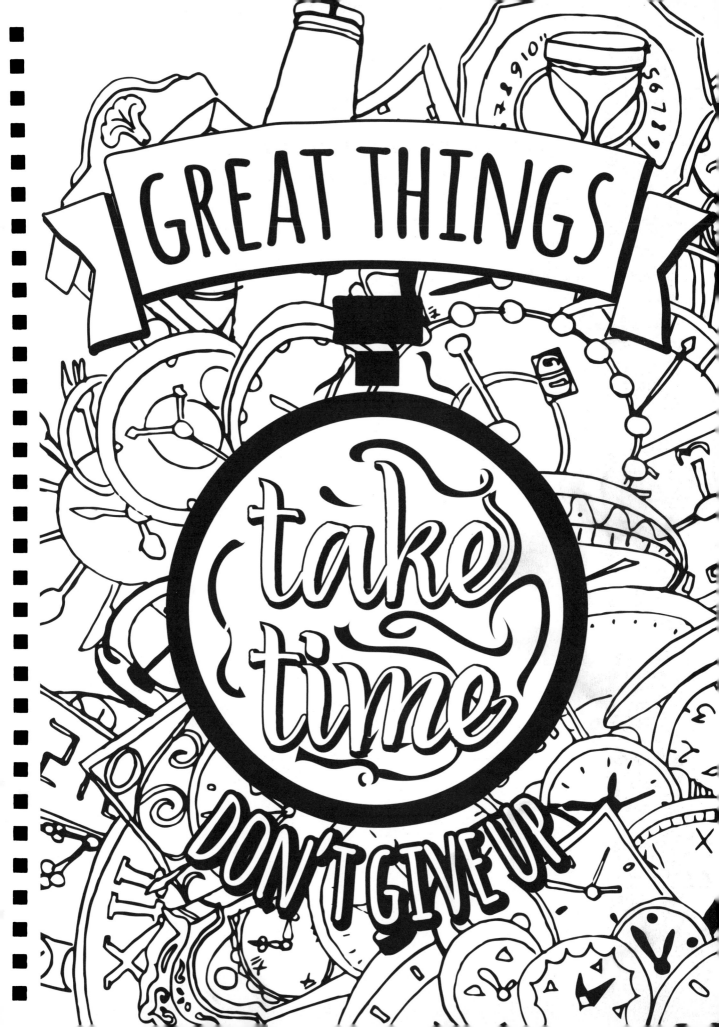

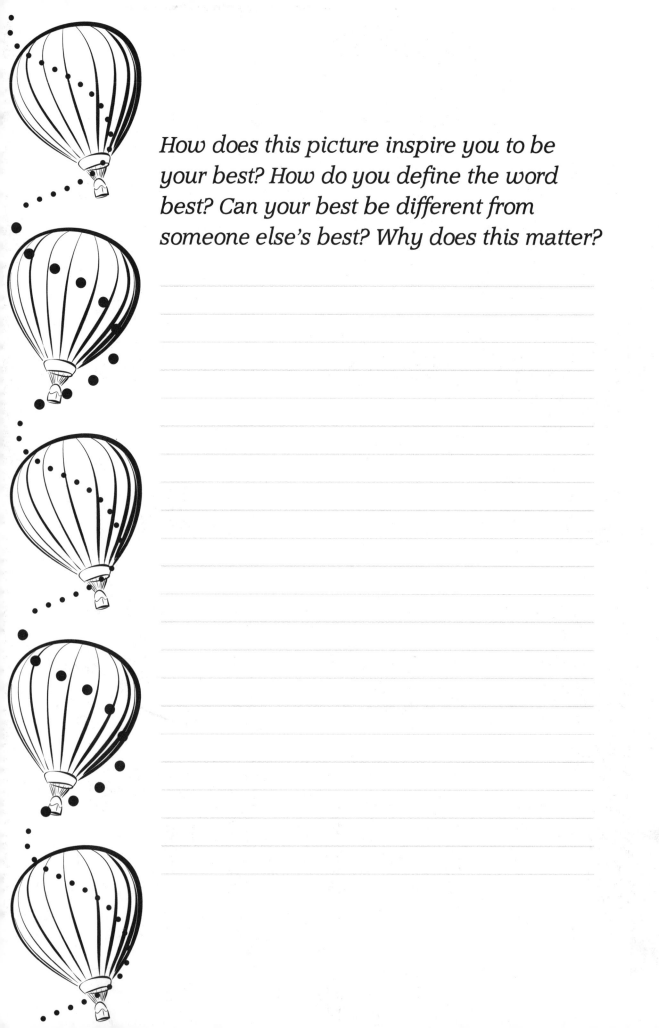

How does this picture inspire you to be your best? How do you define the word best? Can your best be different from someone else's best? Why does this matter?

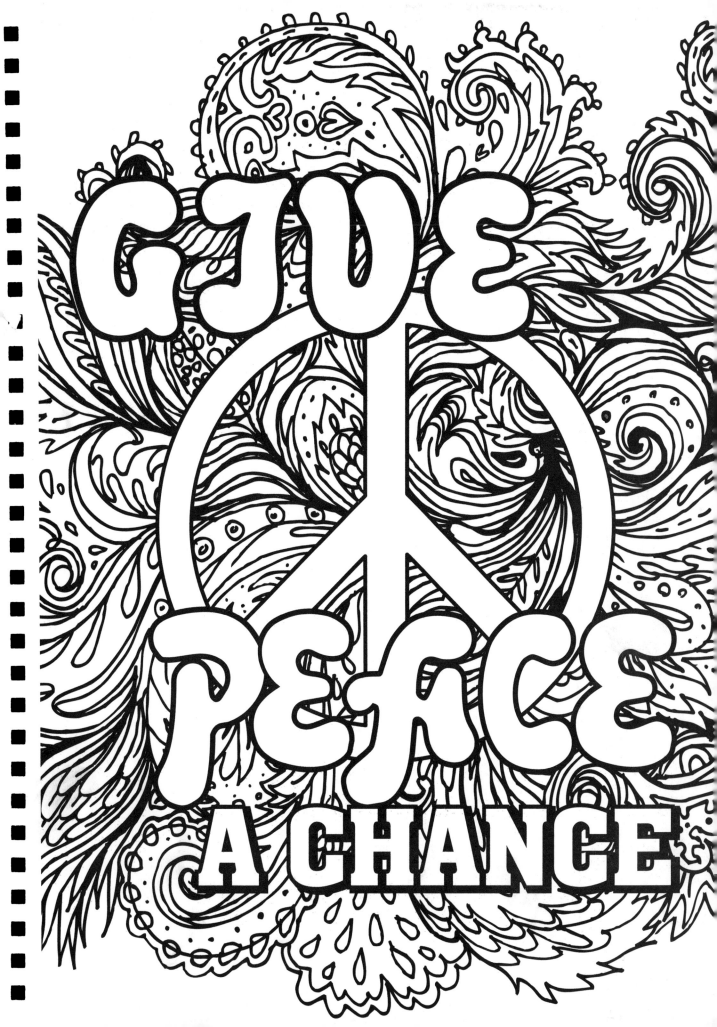

Which is more important to you: peace or truth? Can you have both?

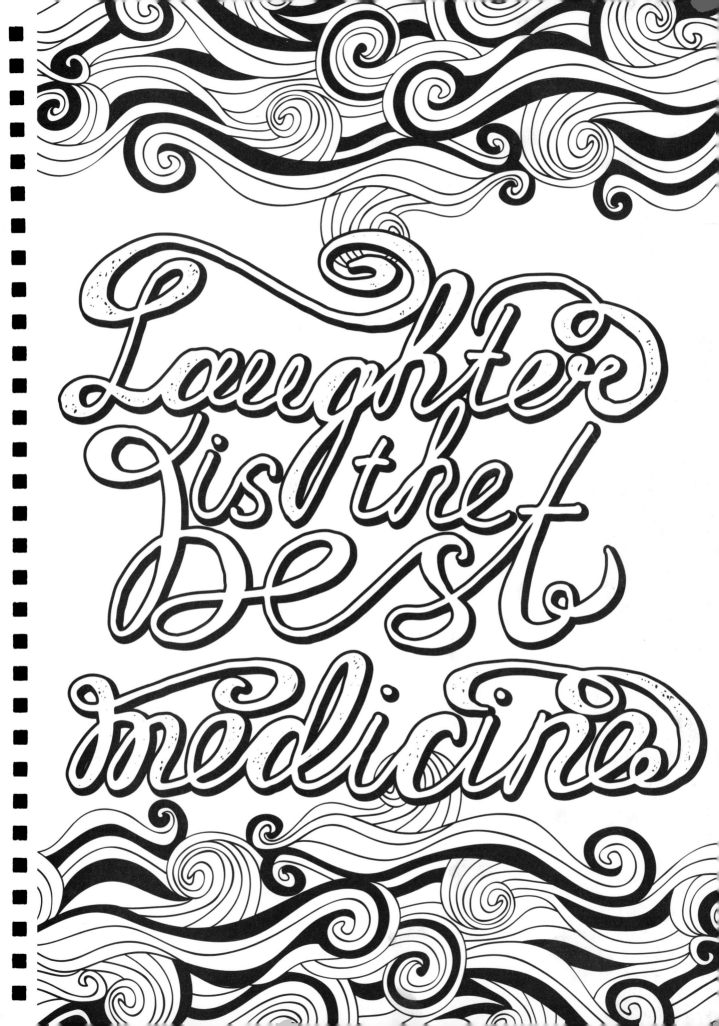

As you color these pages, do your troubles and frustrations melt away? If or when they return, do they seem less troubling and more manageable? Can you get a different perspective on them when you take a break by coloring?

Certain people and places create more beauty in your life. Write about what you consider to be beautiful and inspiring.

Imagine a life without worry. Hard to imagine, isn't it! How does worry damage your life? Write about this. Are there any benefits to worrying? Describe some.

What is it about love that rises above faith and hope?

When you reach out for help and encouragement, who or what helps you stretch a little higher?

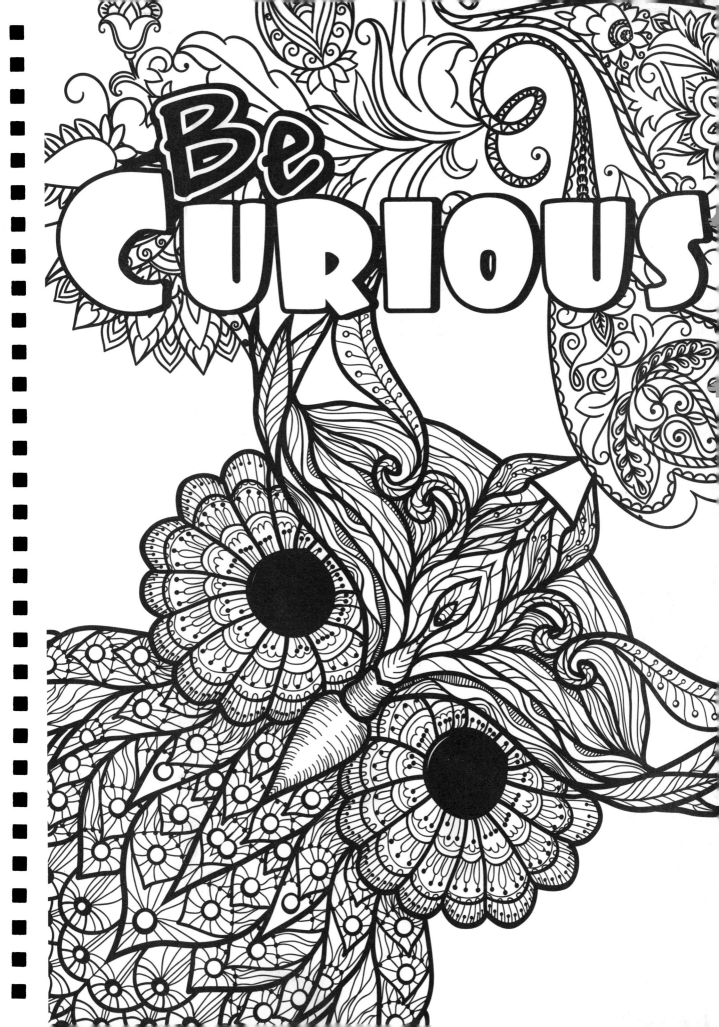

When you work with colored pencils you aren't easily able to erase your work. If you have to live with your choices, how can you turn what you think is a mistake into a new masterpiece? How is this like the rest of your life? How can you turn mistakes into magic?

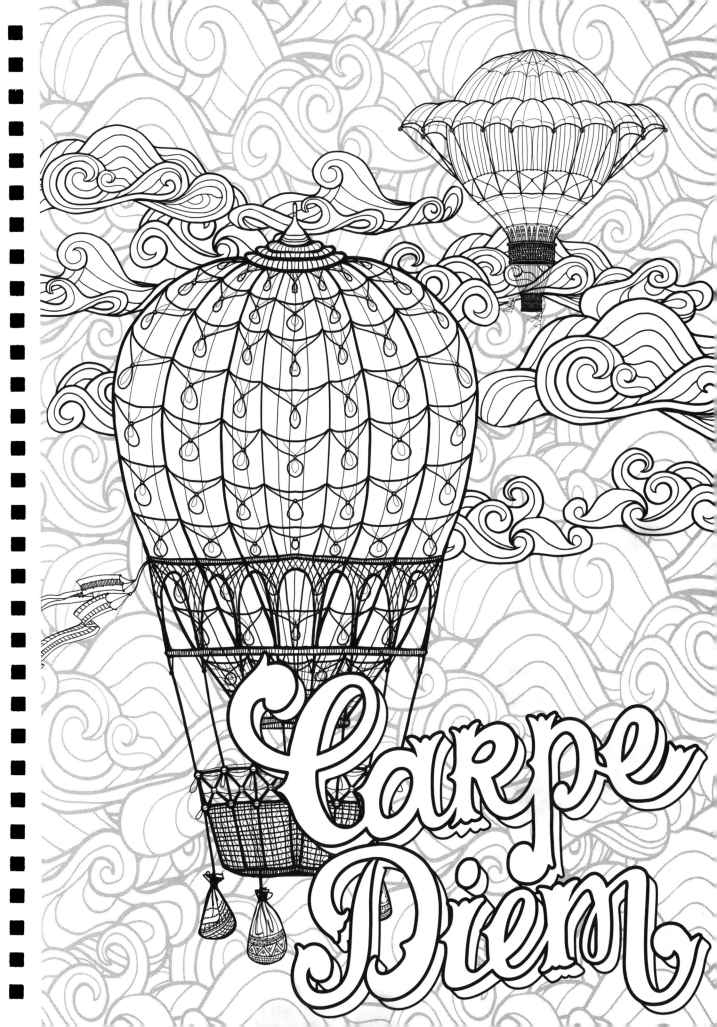

Nothing is Impossible

Therapy *is from the original word for healing. How does Art Therapy heal your stress and anxiety?*

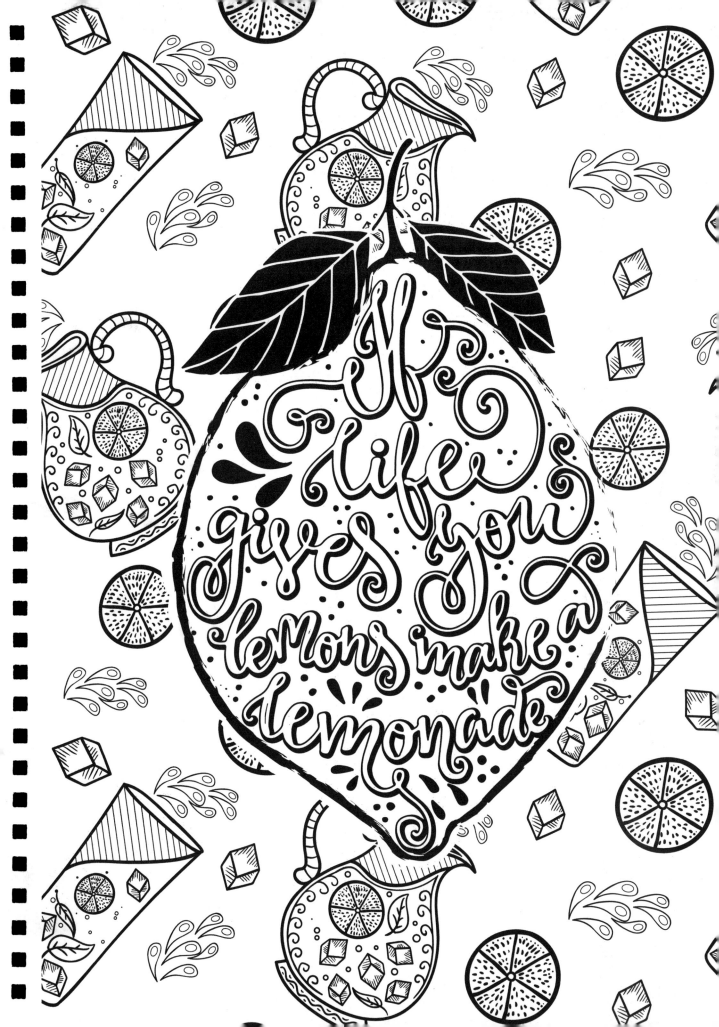

What does the word inspirational *mean to you? Write about your desire or responsibility to inspire others.*

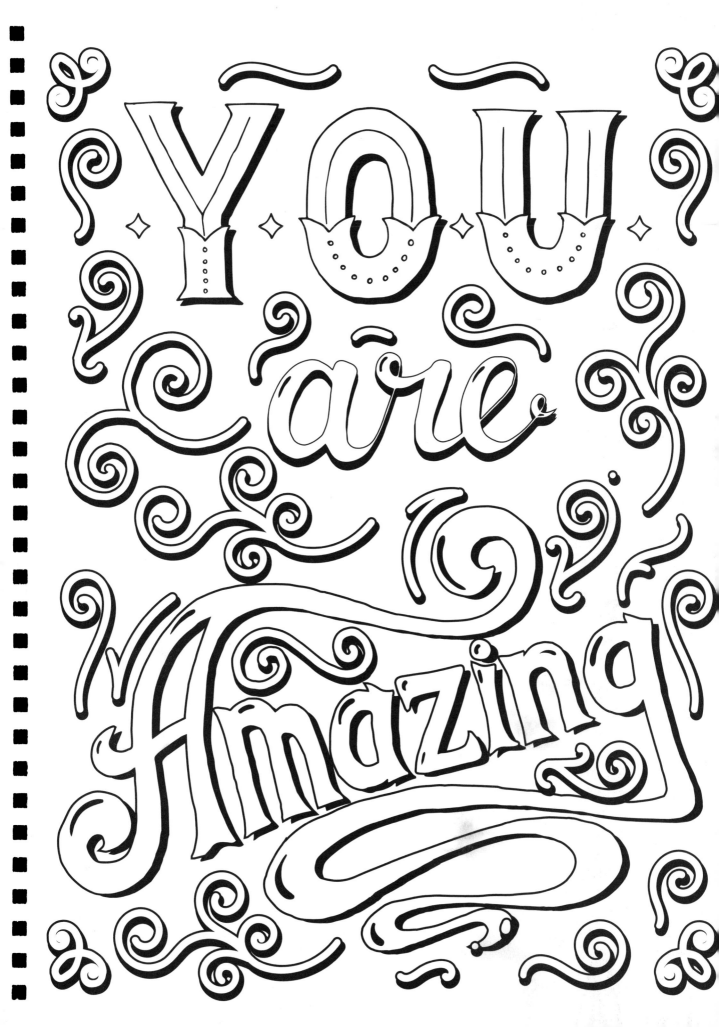

It is difficult and even painful sometimes to let go of past hurts and regrets. When you hang on it can drag you along and wear you down and out. Write about something that you are having a hard time letting go of. How can you lay it down each day, little by little?

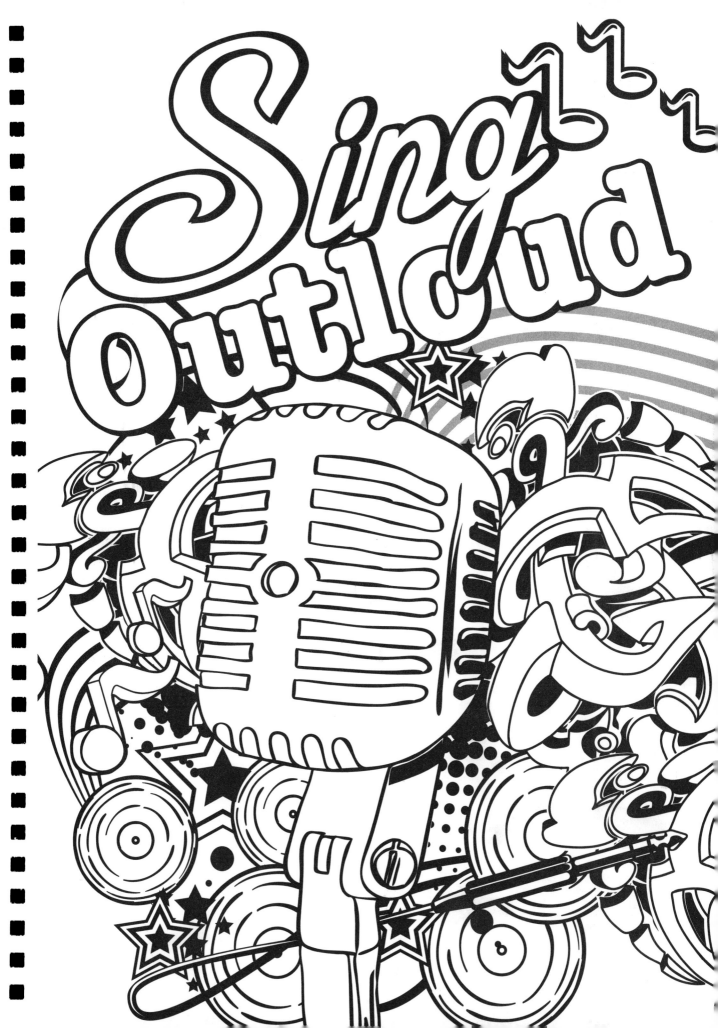

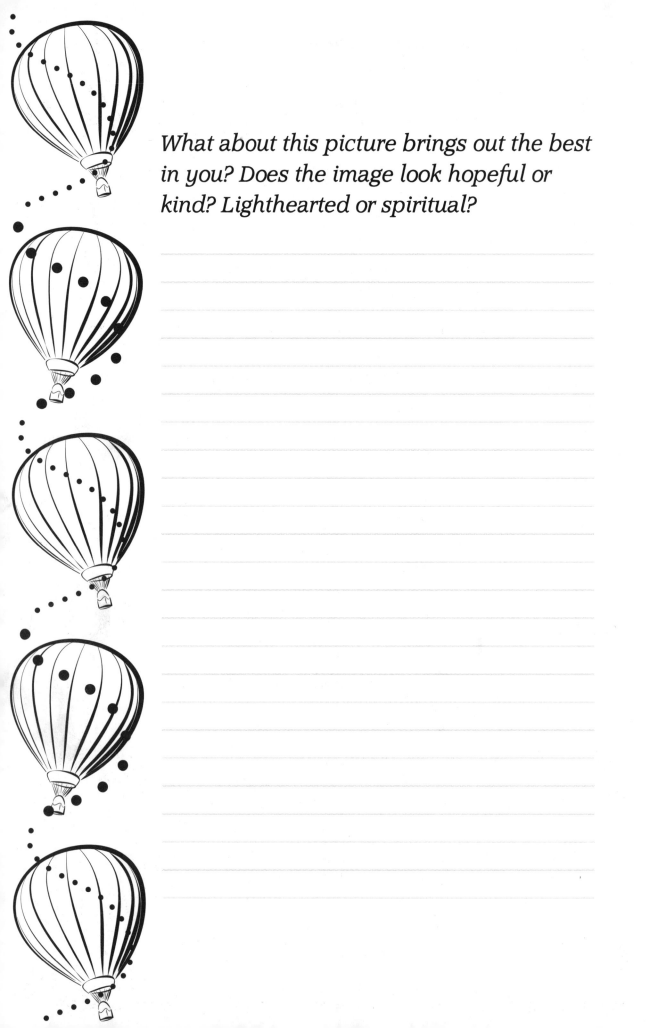

What about this picture brings out the best in you? Does the image look hopeful or kind? Lighthearted or spiritual?

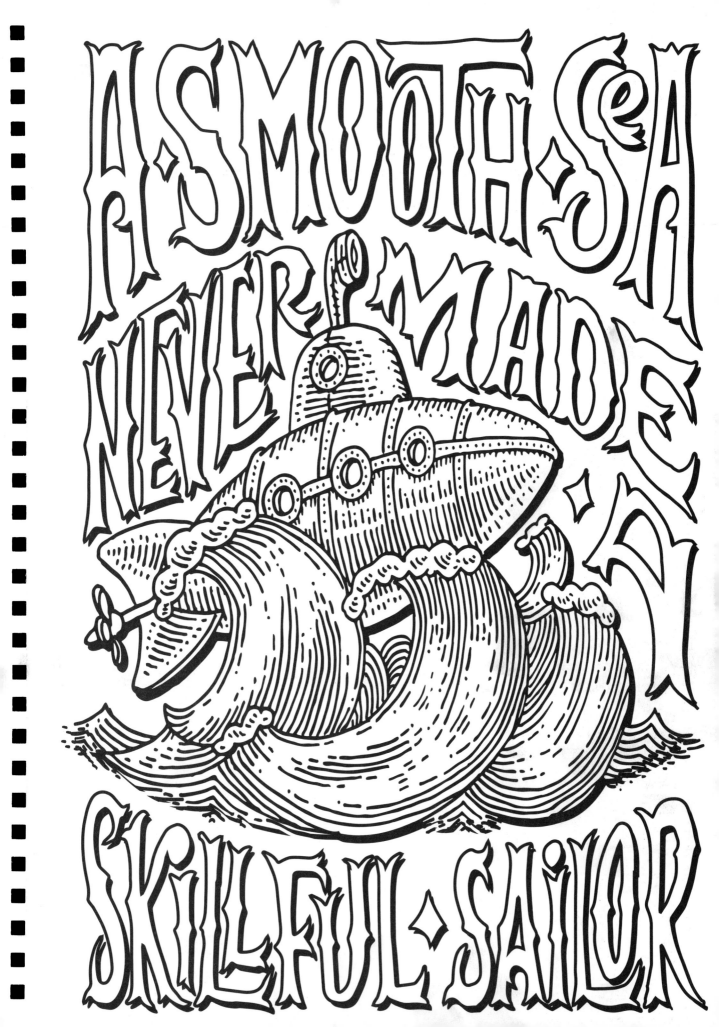

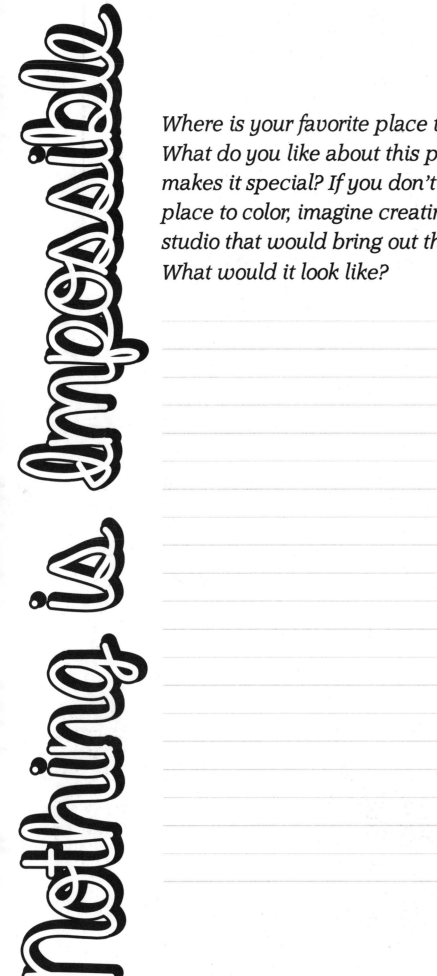

Where is your favorite place to color?
What do you like about this place, and what
makes it special? If you don't have a favorite
place to color, imagine creating a kind of art
studio that would bring out the best in you.
What would it look like?

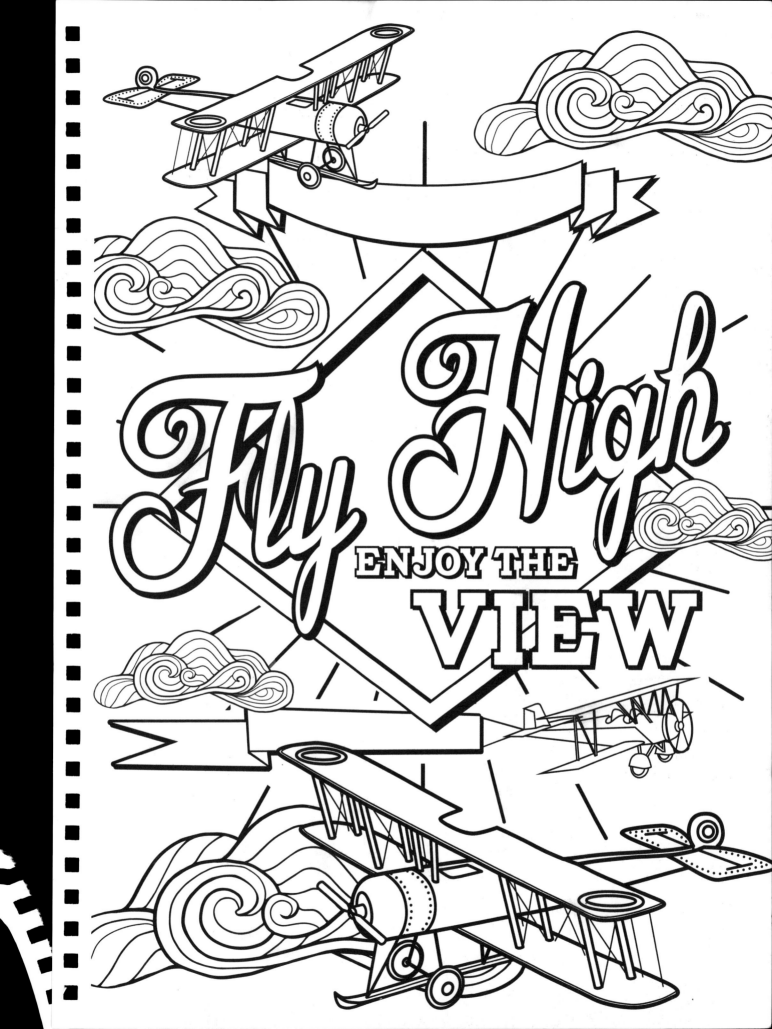

When you reflect on this picture, think about what you hope for in life. What are your hopes for today?

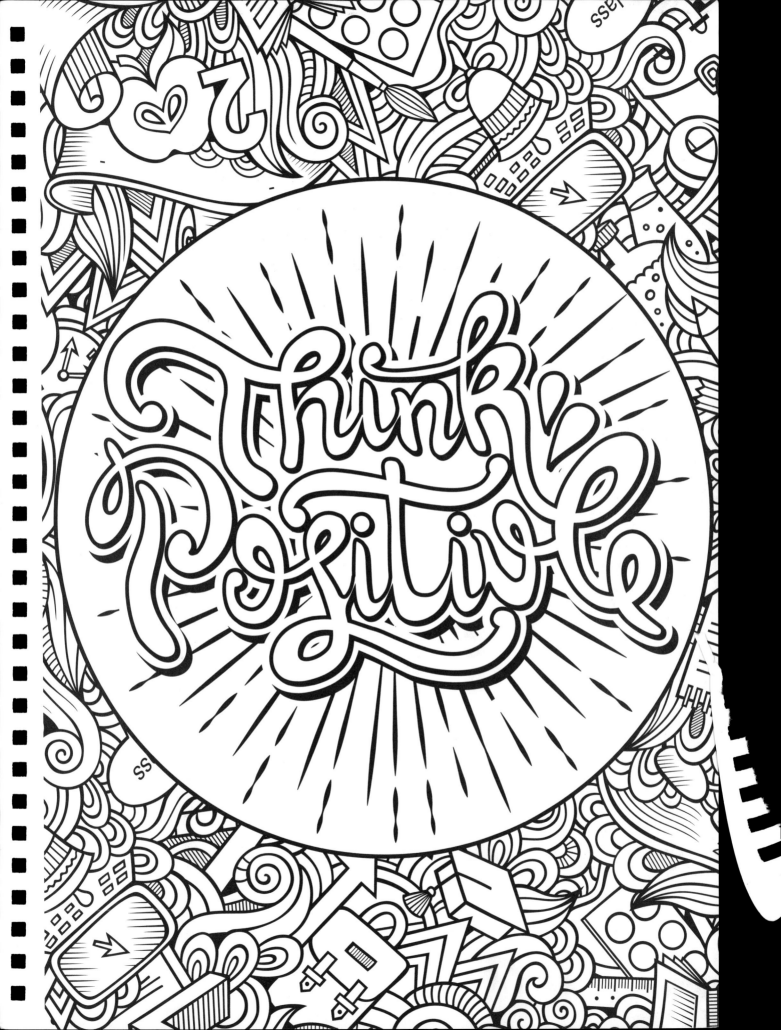

nothing is impossible

Do you think you are a better person in the presence of certain people? Who are they, and how can you increase their presence in your life?

In the chaos of everyday living, how difficult is it for you to be still? Write about how stillness can help you.

Write about how over-thinking can keep you from being thankful.

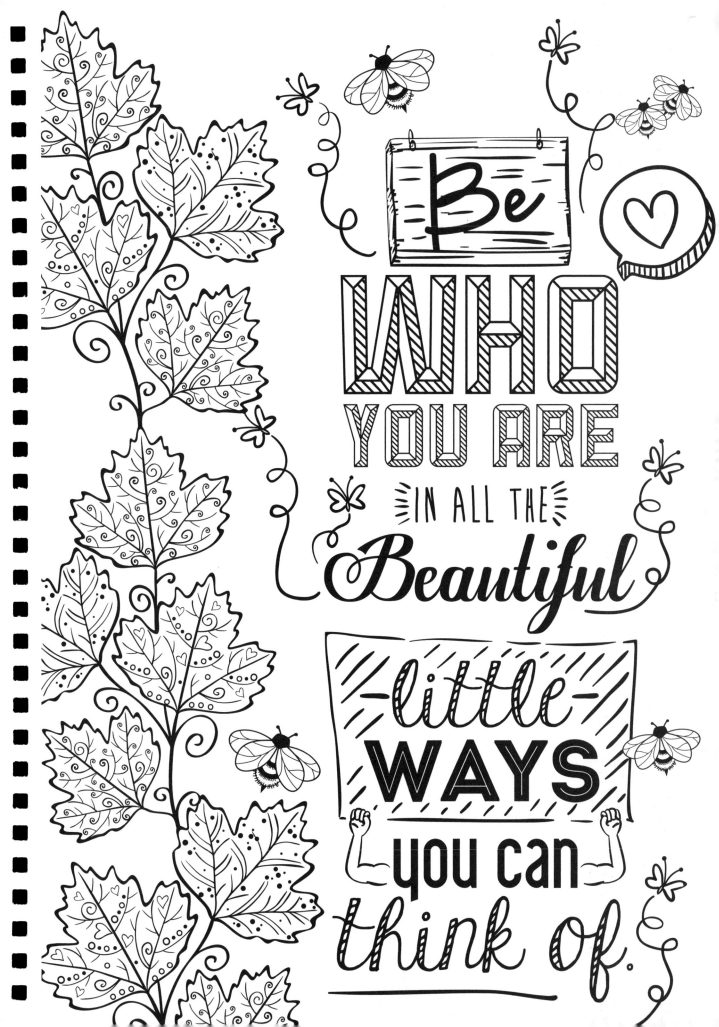

Be WHO YOU ARE IN ALL THE Beautiful -little- WAYS you can think of.

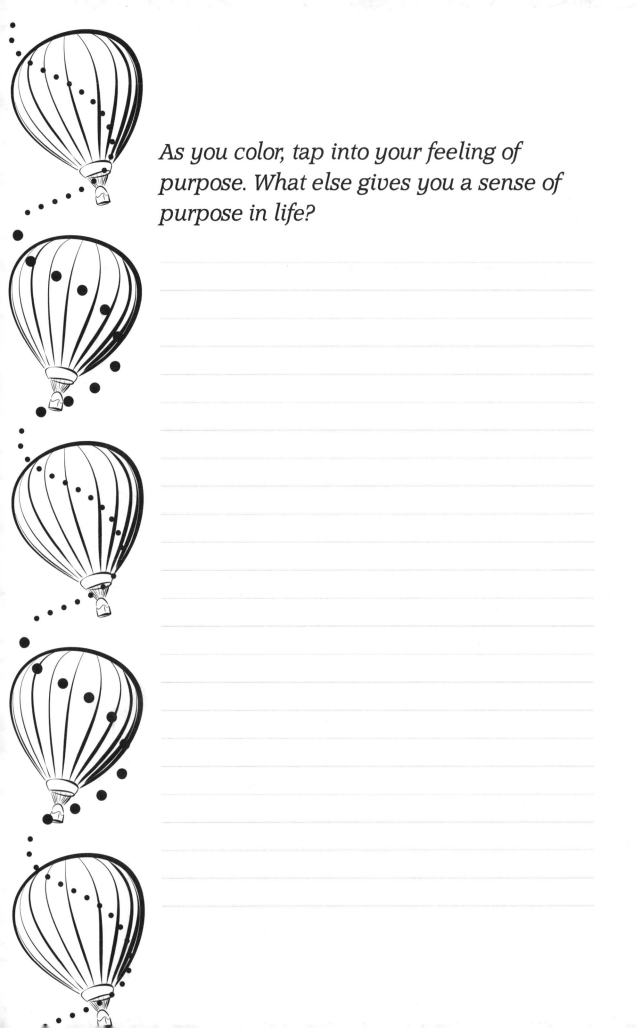

As you color, tap into your feeling of purpose. What else gives you a sense of purpose in life?

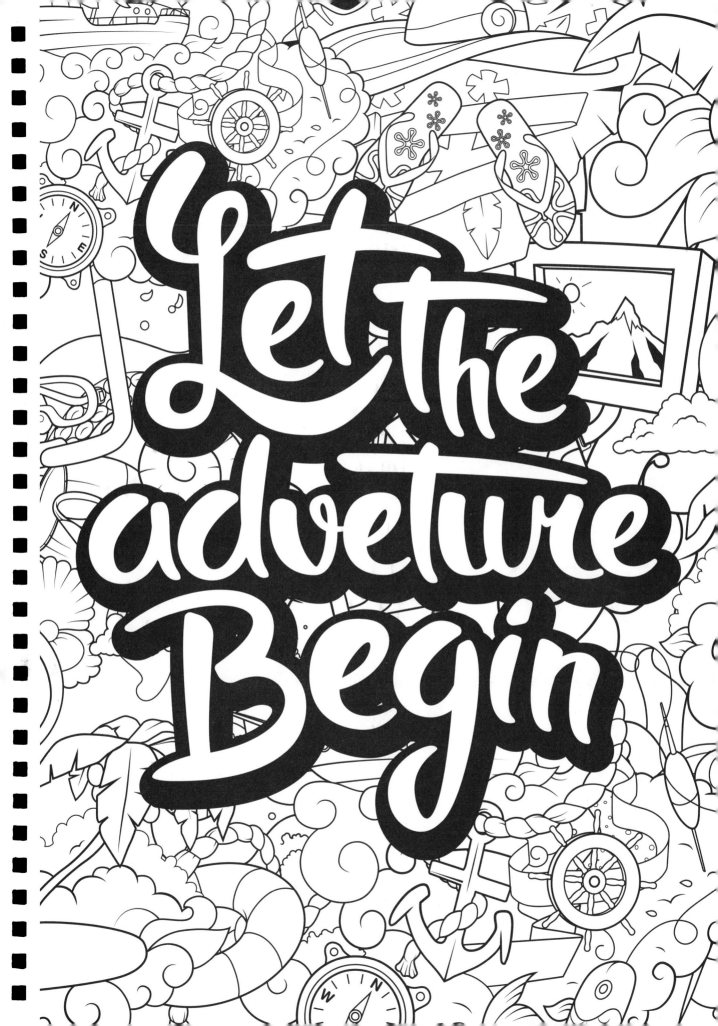

Nothing is Impossible

What do you have in common with this picture? Is it happy or serious? Whimsical or realistic?

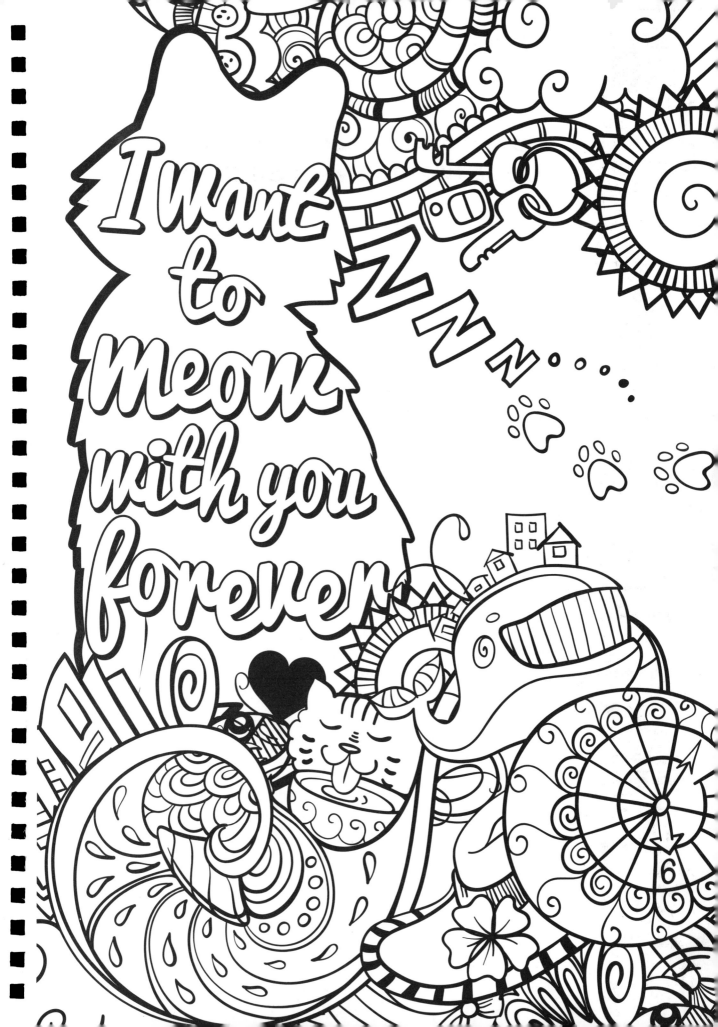

What about this picture makes you grateful? What are you grateful for?